Dedication

To my friends.

In no way do I consider myelf an "artist", but none-the-less, I have had a wonderful time working and creating these pictures.

I invite and encourage you to do the same.

Your efforts and work could be the ONE THING that causes others to feel better about what THEY can do!

Judy Tunstall

Please do not copy these pictures without our permission.
contact Marian Brickner insect1@att.net

26

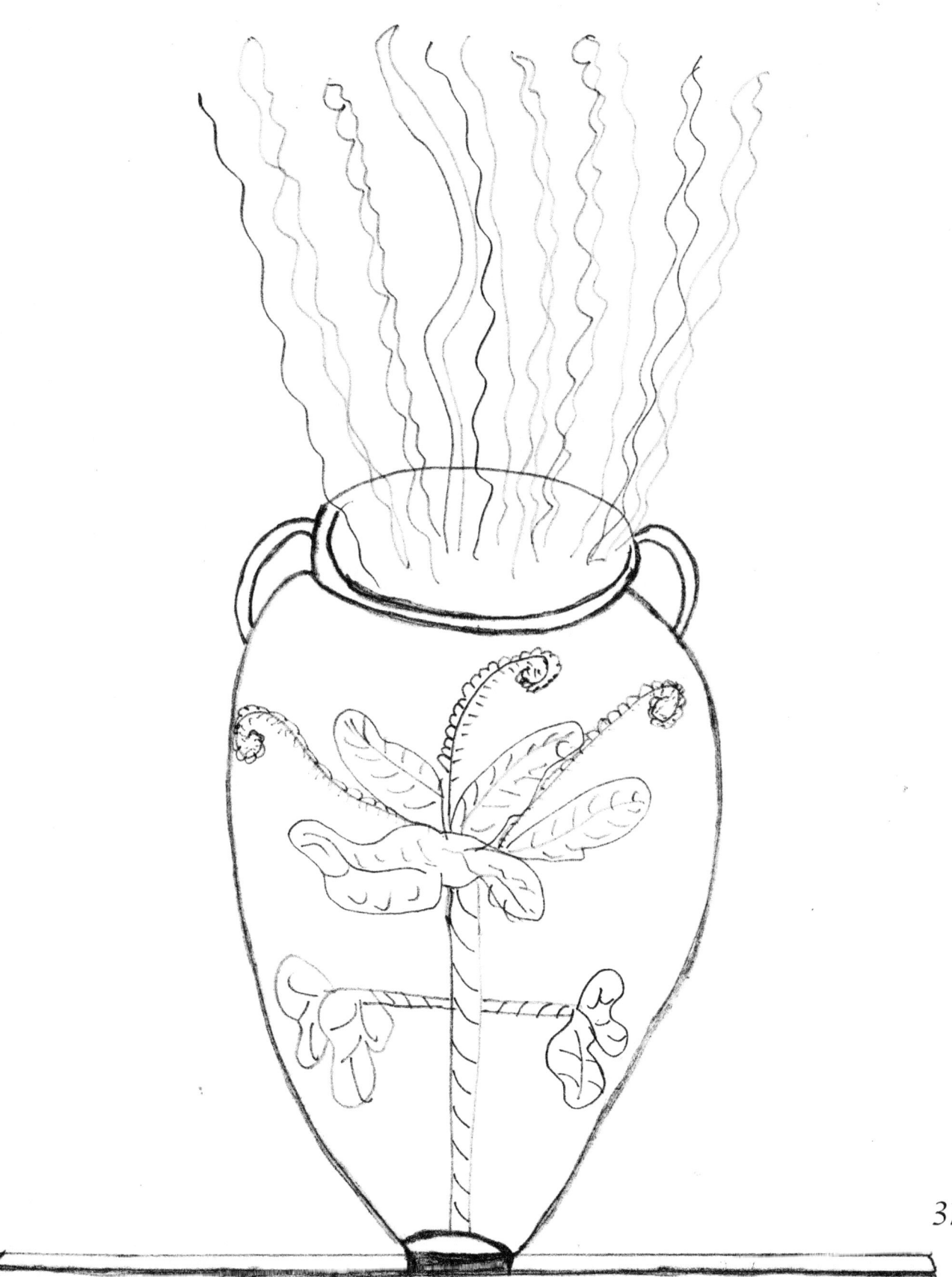

37

www.ingramcontent.com/pod-product-compliance
Lightning Source LLC
Chambersburg PA
CBHW080523190526
45169CB00008B/3033